The Pug Lovers Coloring Book

By Mindful Coloring Books

Copyright © 2016 by Mindful Coloring Books

All rights reserved. No part of this publication may be reproduced, distributed, or transmitted in any form or by any means, including photocopying, recording, or other electronic or mechanical methods.

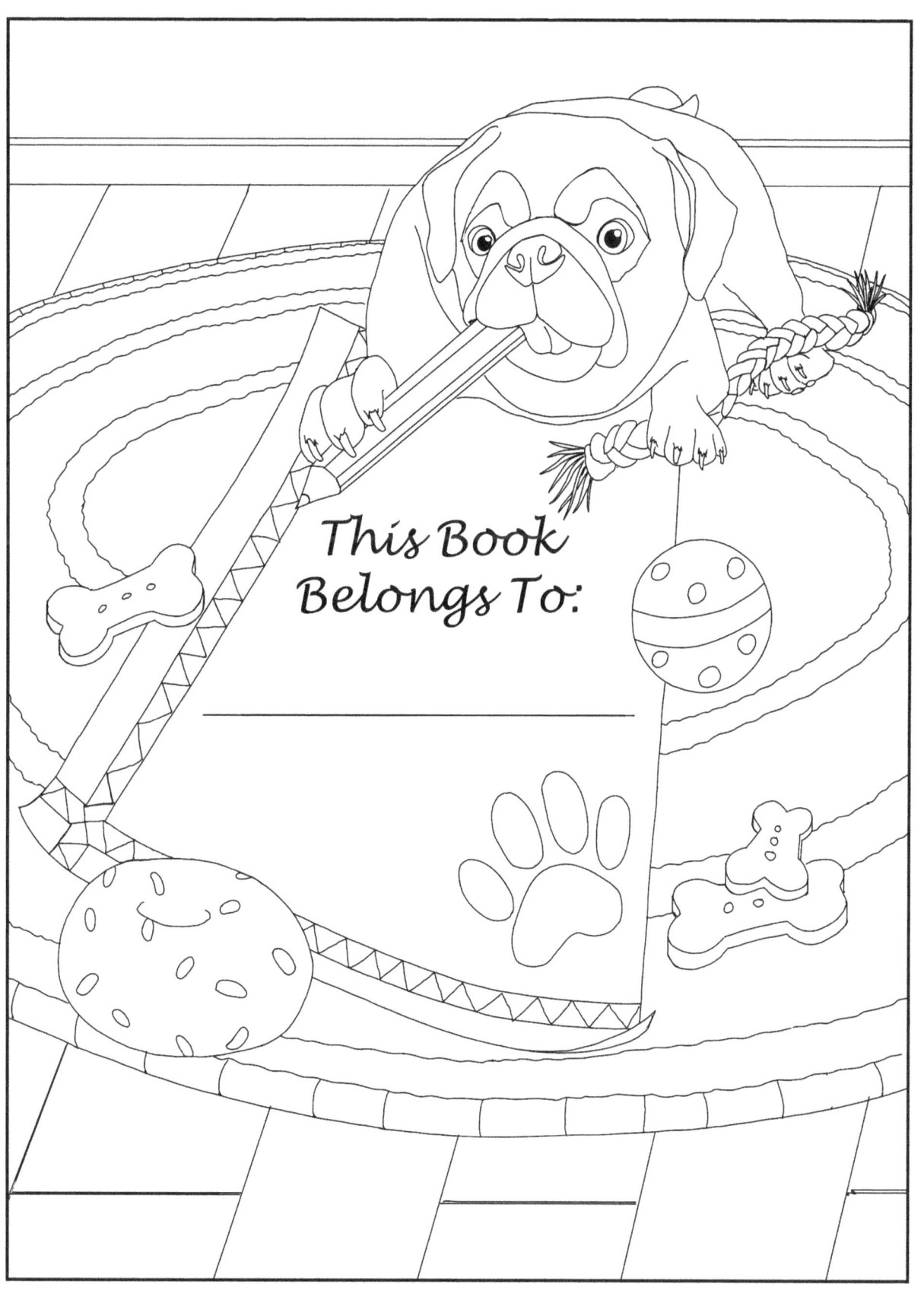

Coloring Tips

~ Sometimes what you think the color will look like and what it will actually look like are very different. Use the color test page.

~ Don't press too hard. Start out coloring lightly and you can always go back and make it darker.

~ Keep your pencil tips sharp so you can get into all the intricate spaces.

~ Using markers? Place a scrap piece of paper behind the page you are coloring. Pages in this book are only printed on one side but there is still the risk of bleed through to the next page.

~ Try different coloring utensils marketed for adults. It is fun and quality can vary greatly.

COLOR TEST PAGE

COLOR TEST PAGE

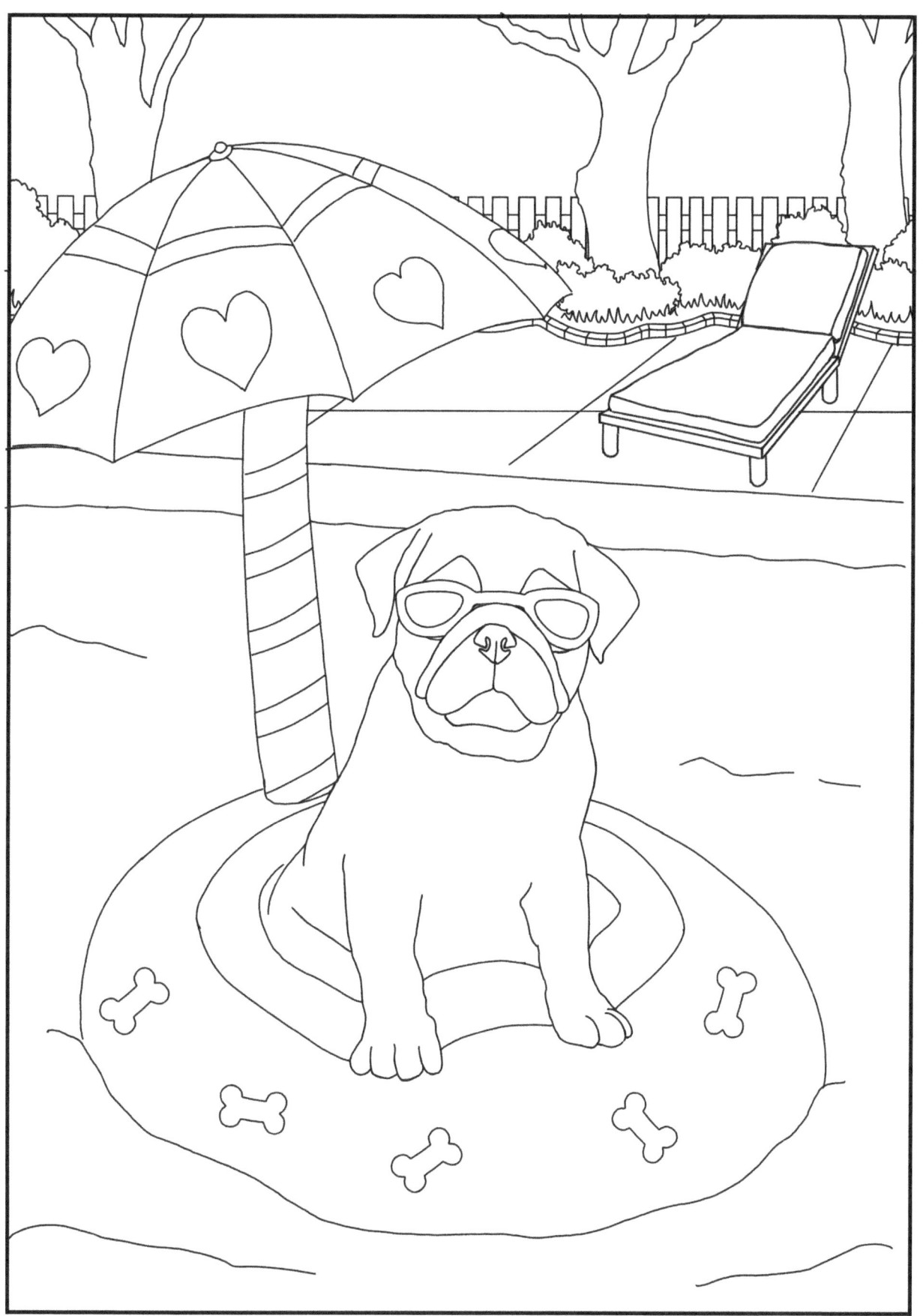

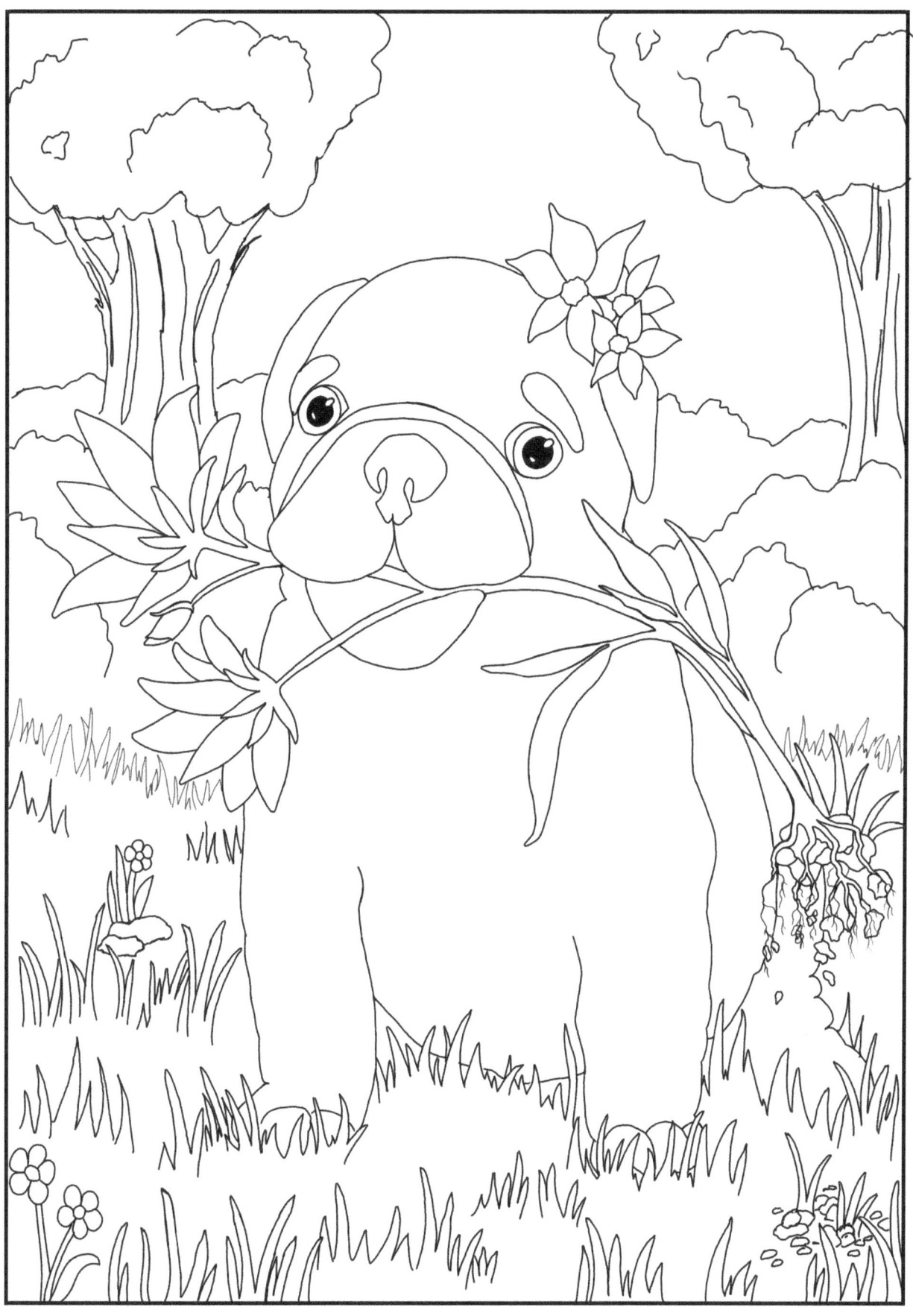

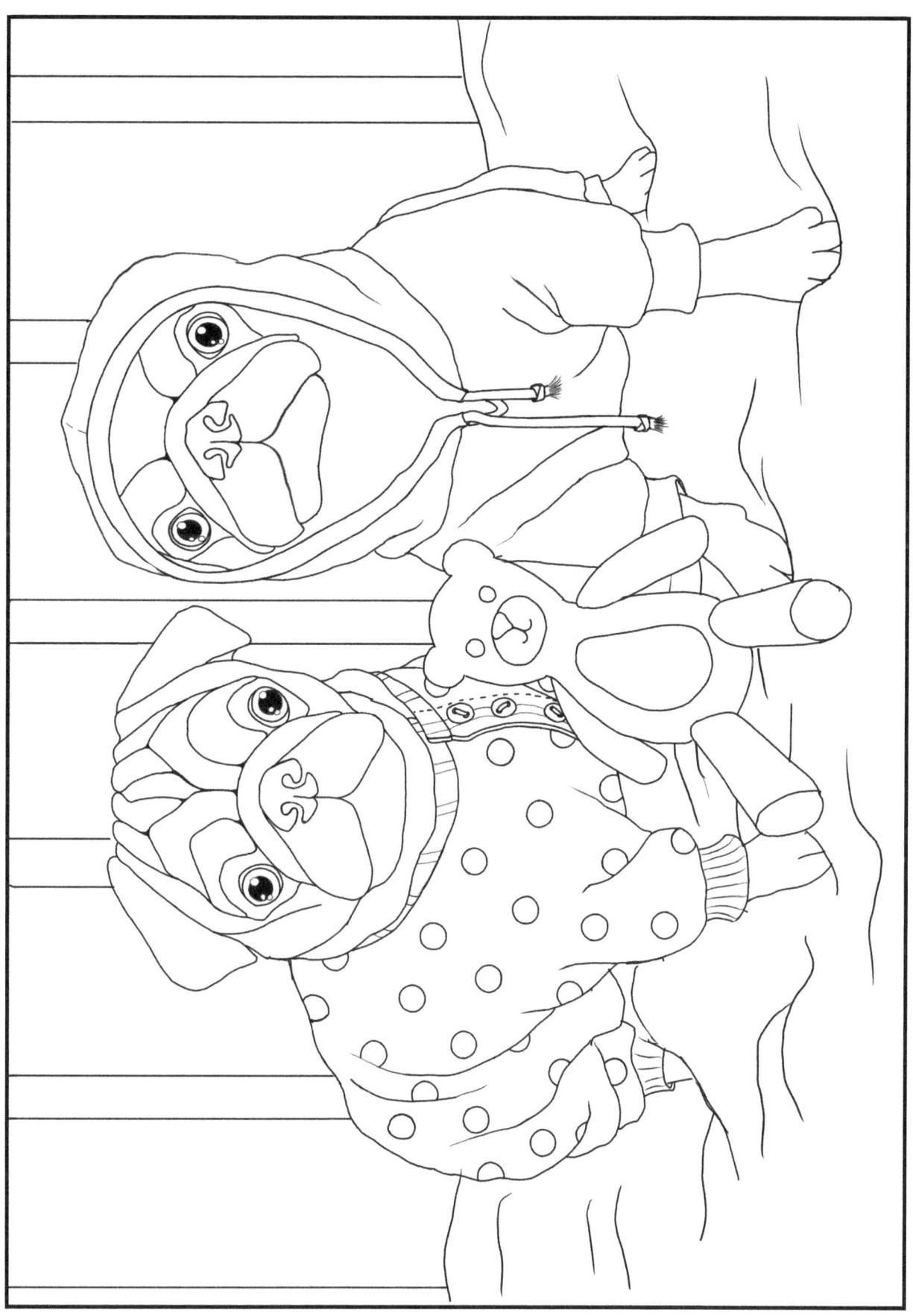

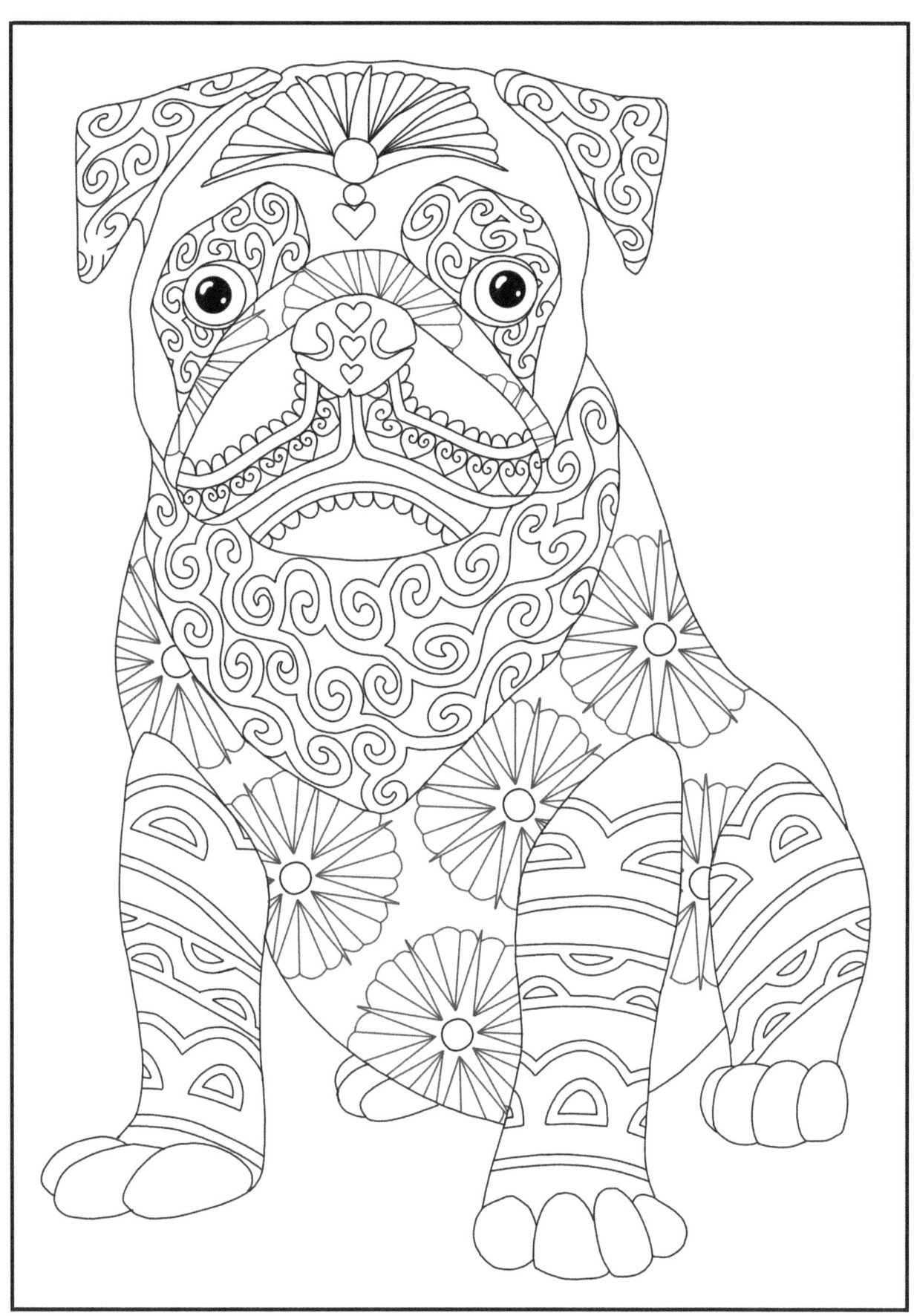

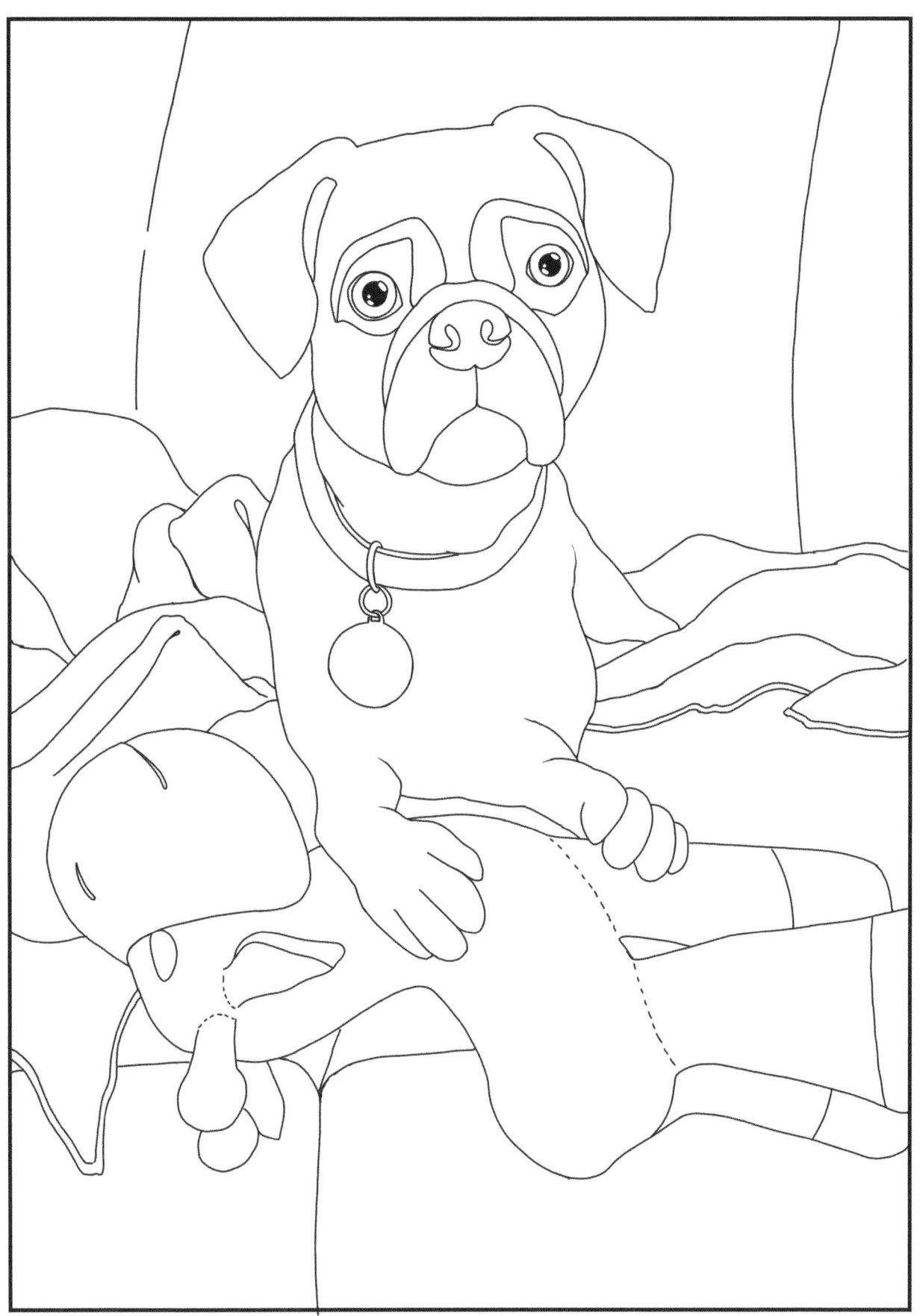

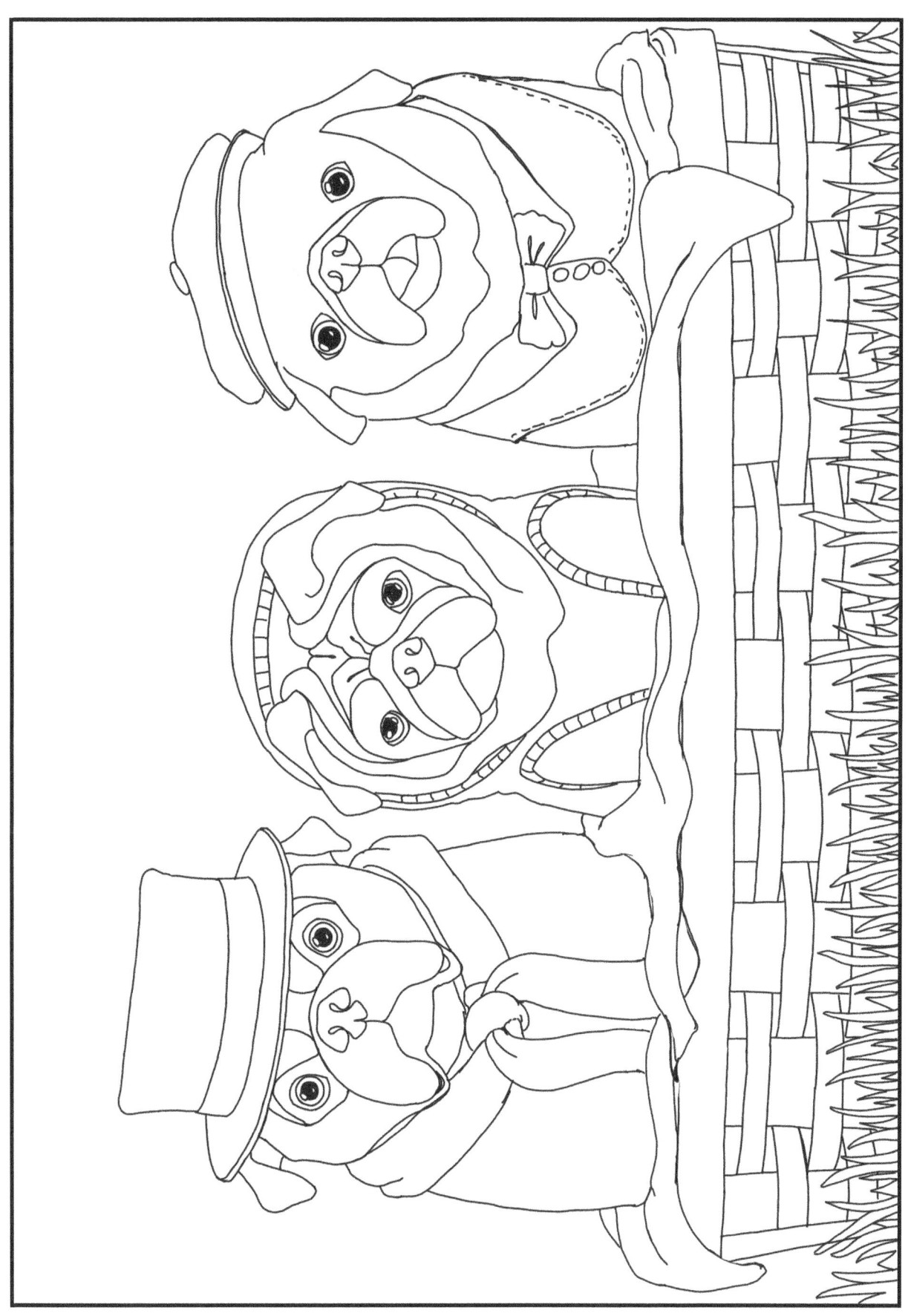

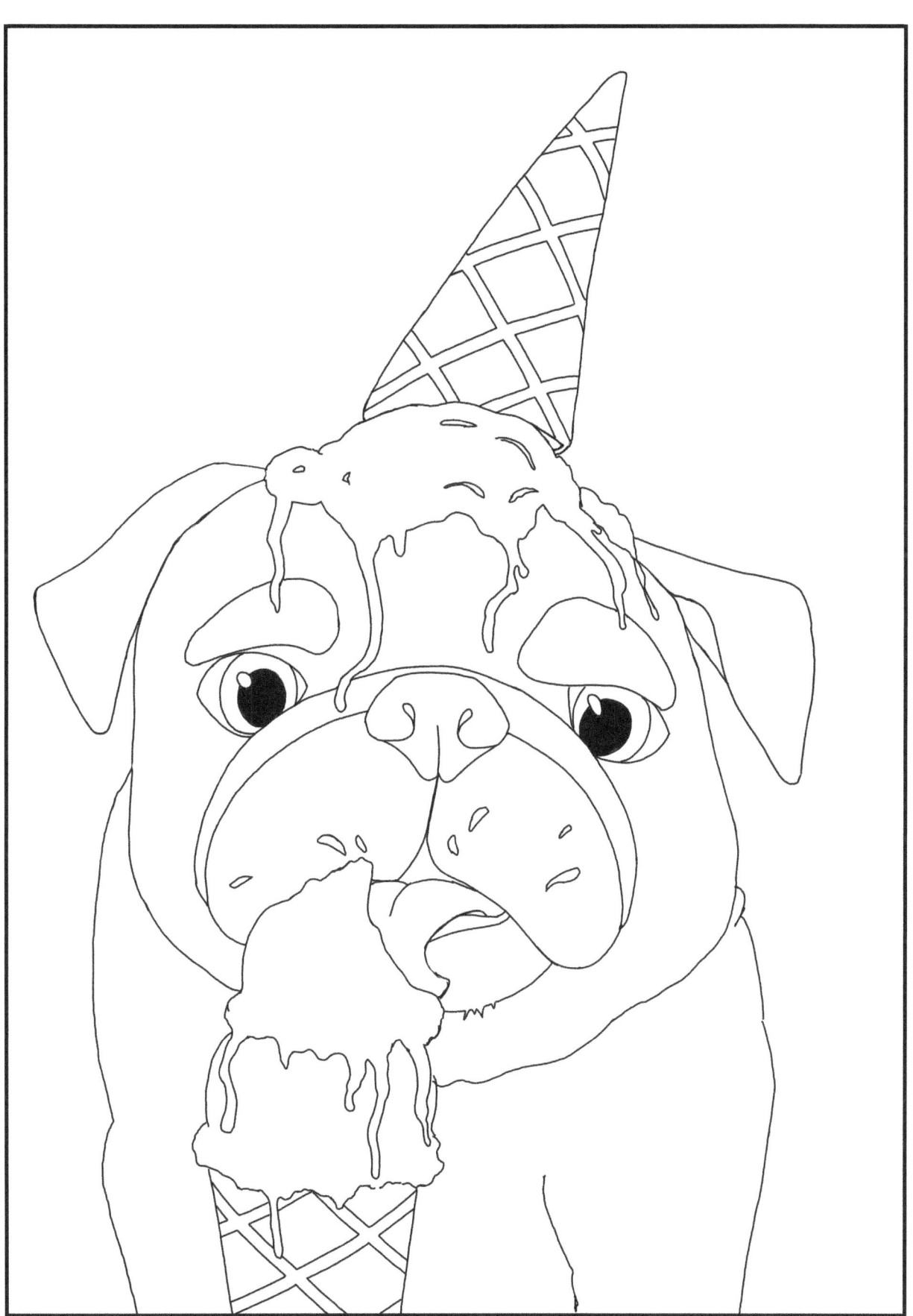

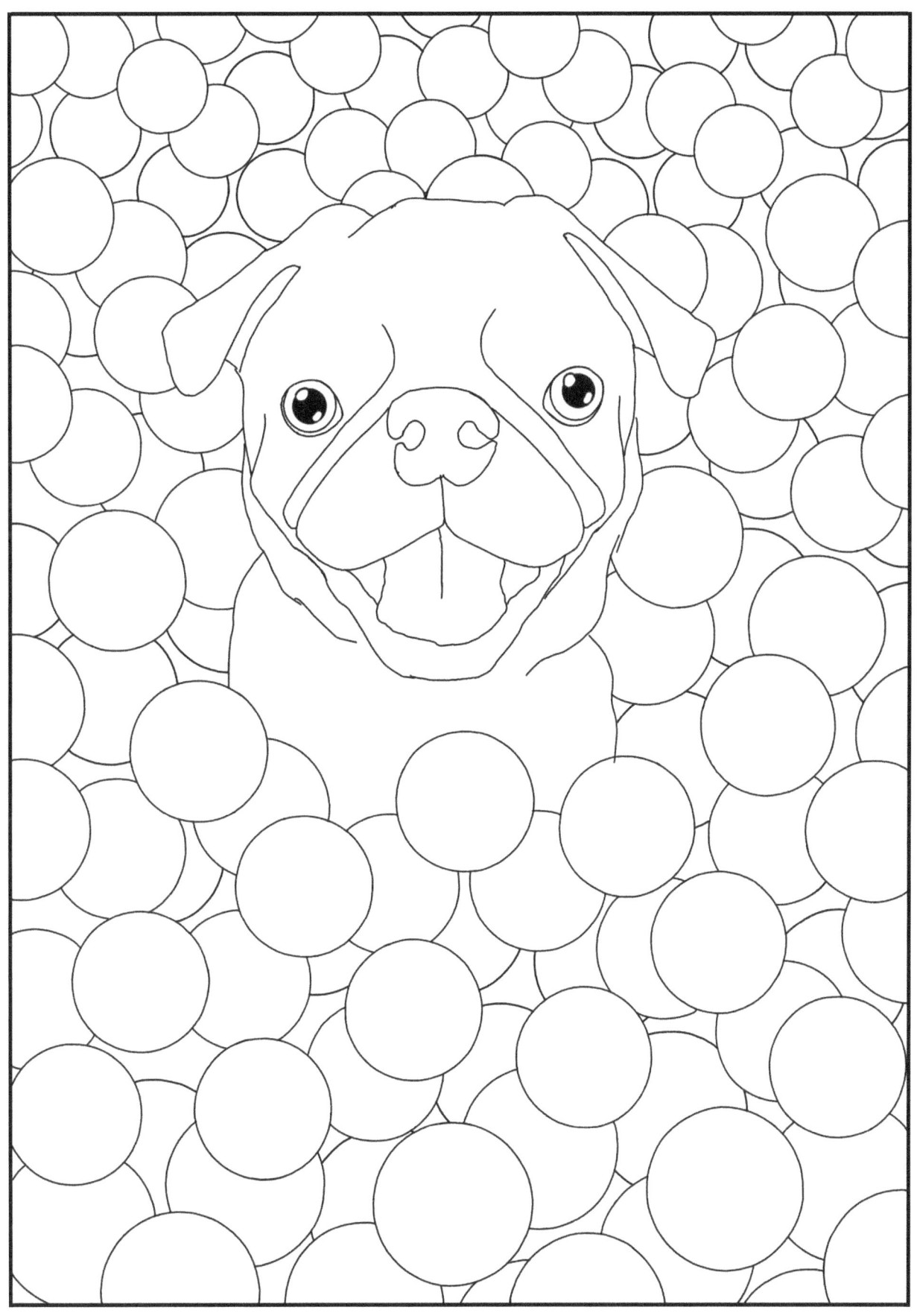

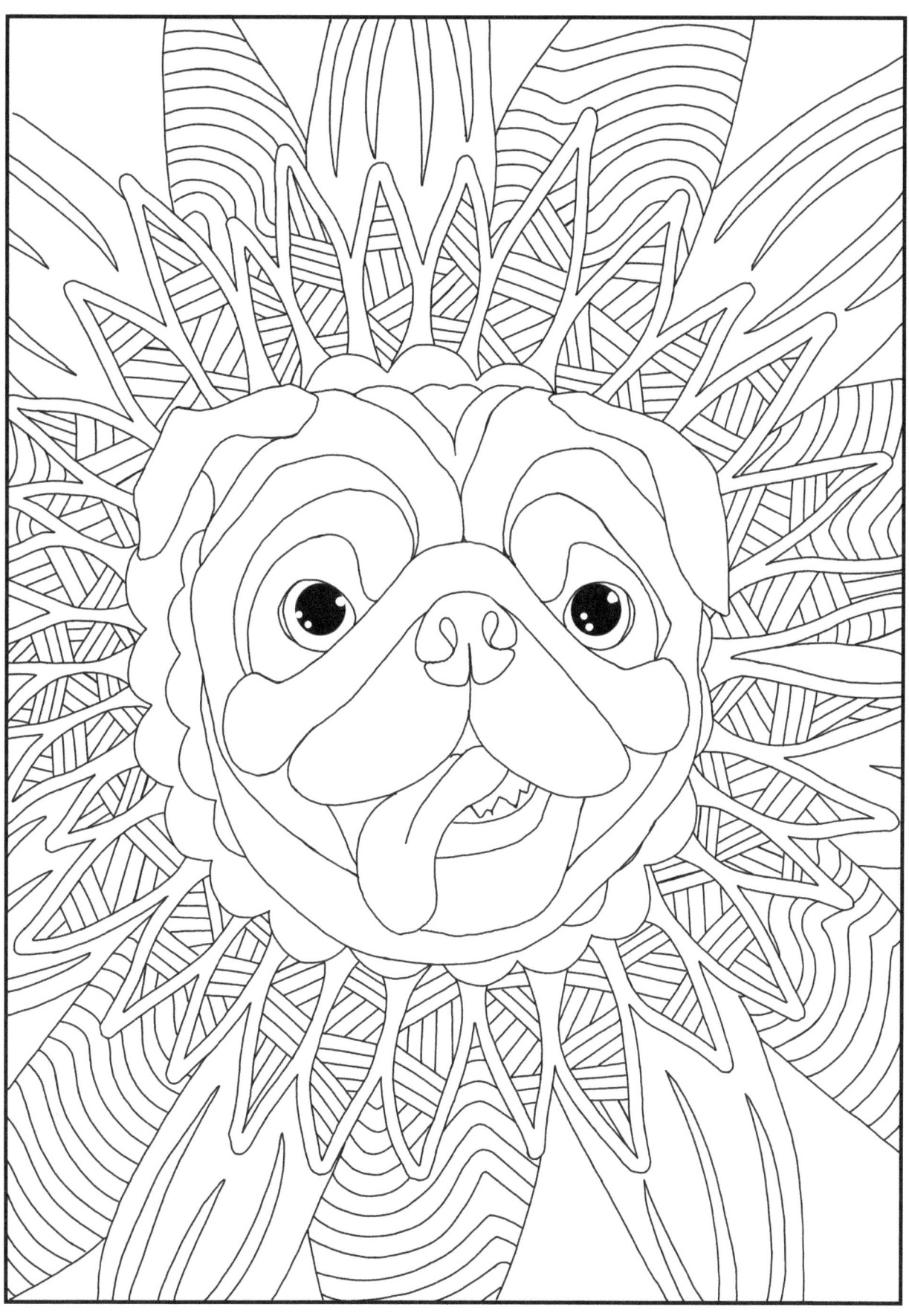

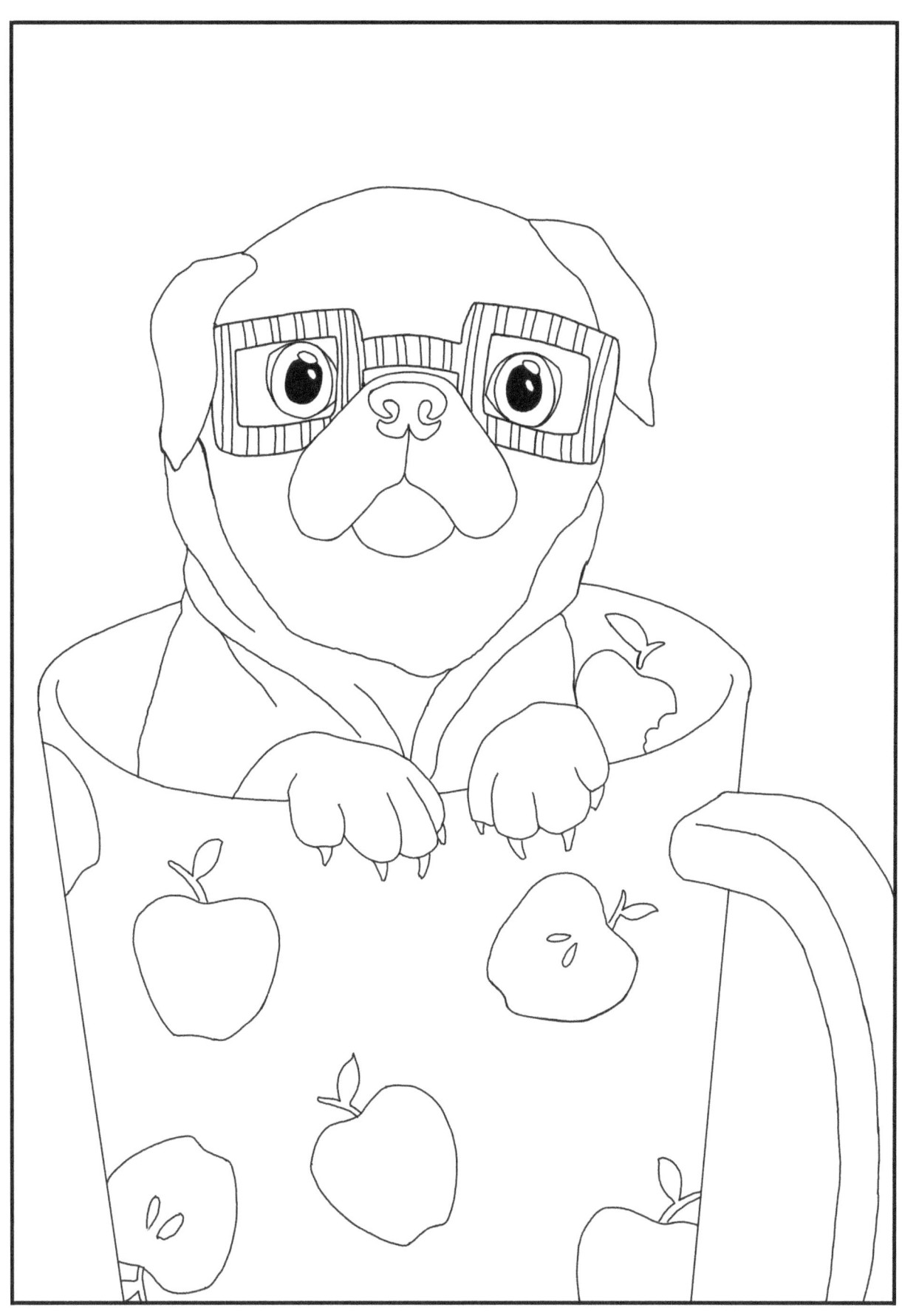

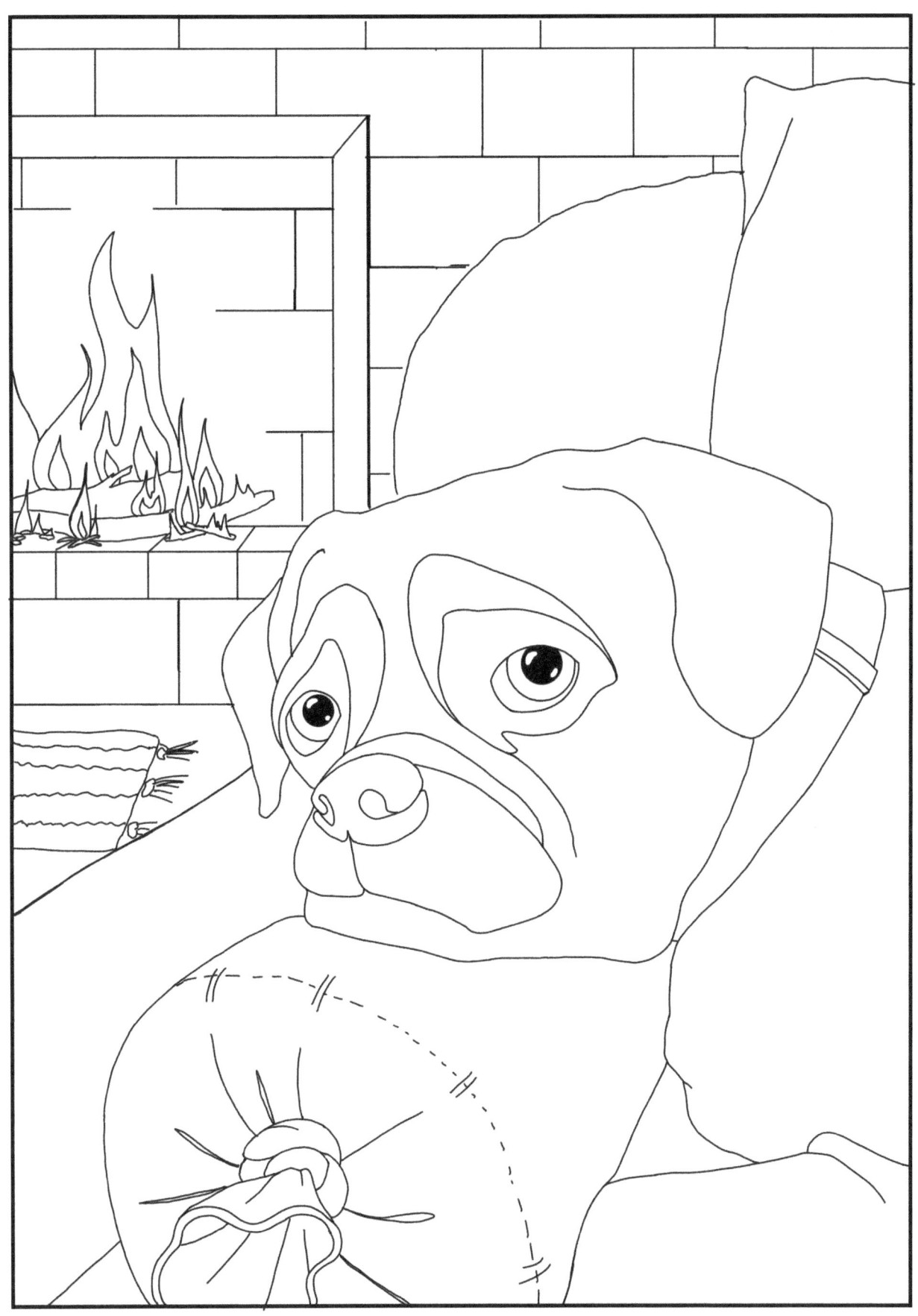

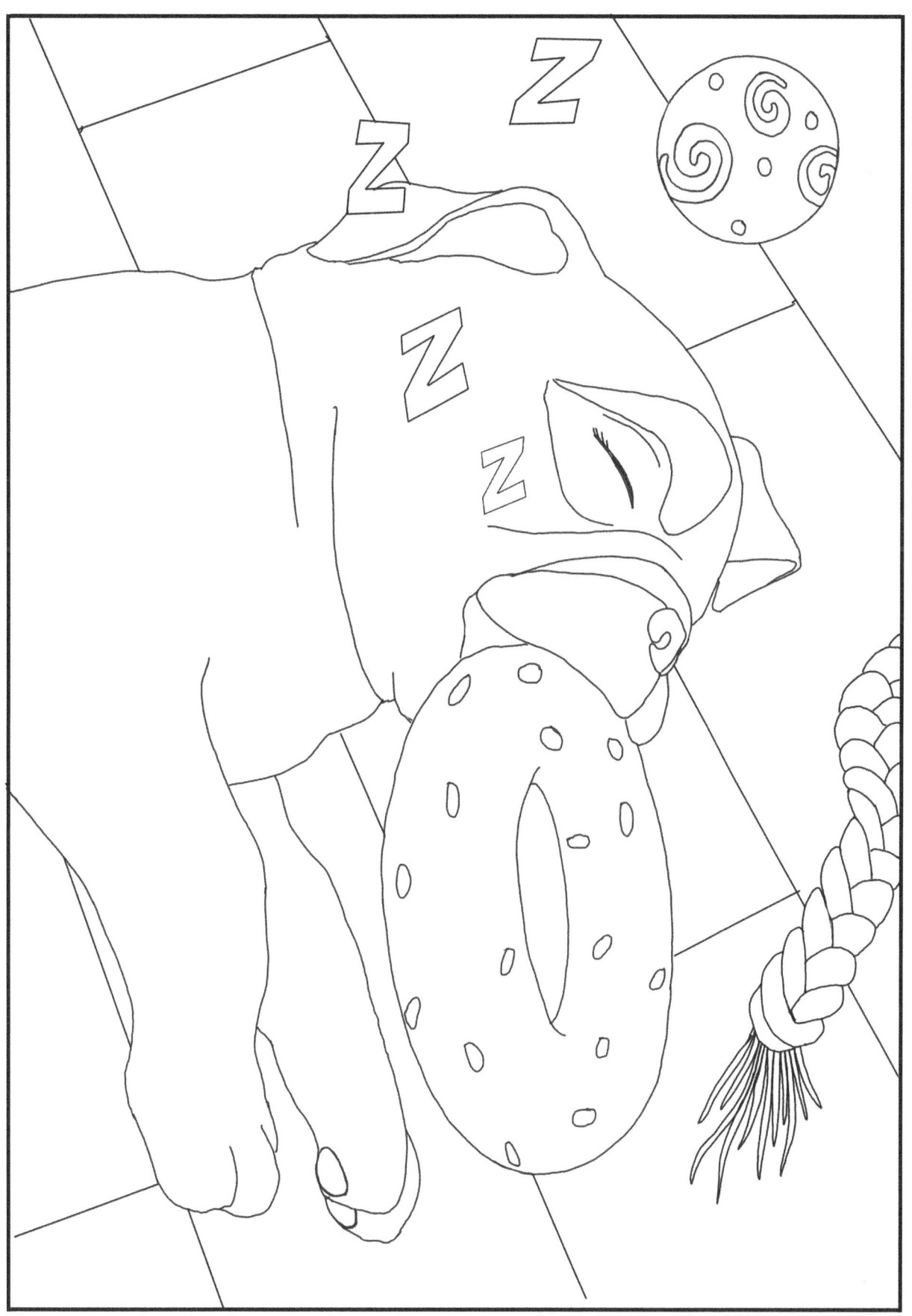

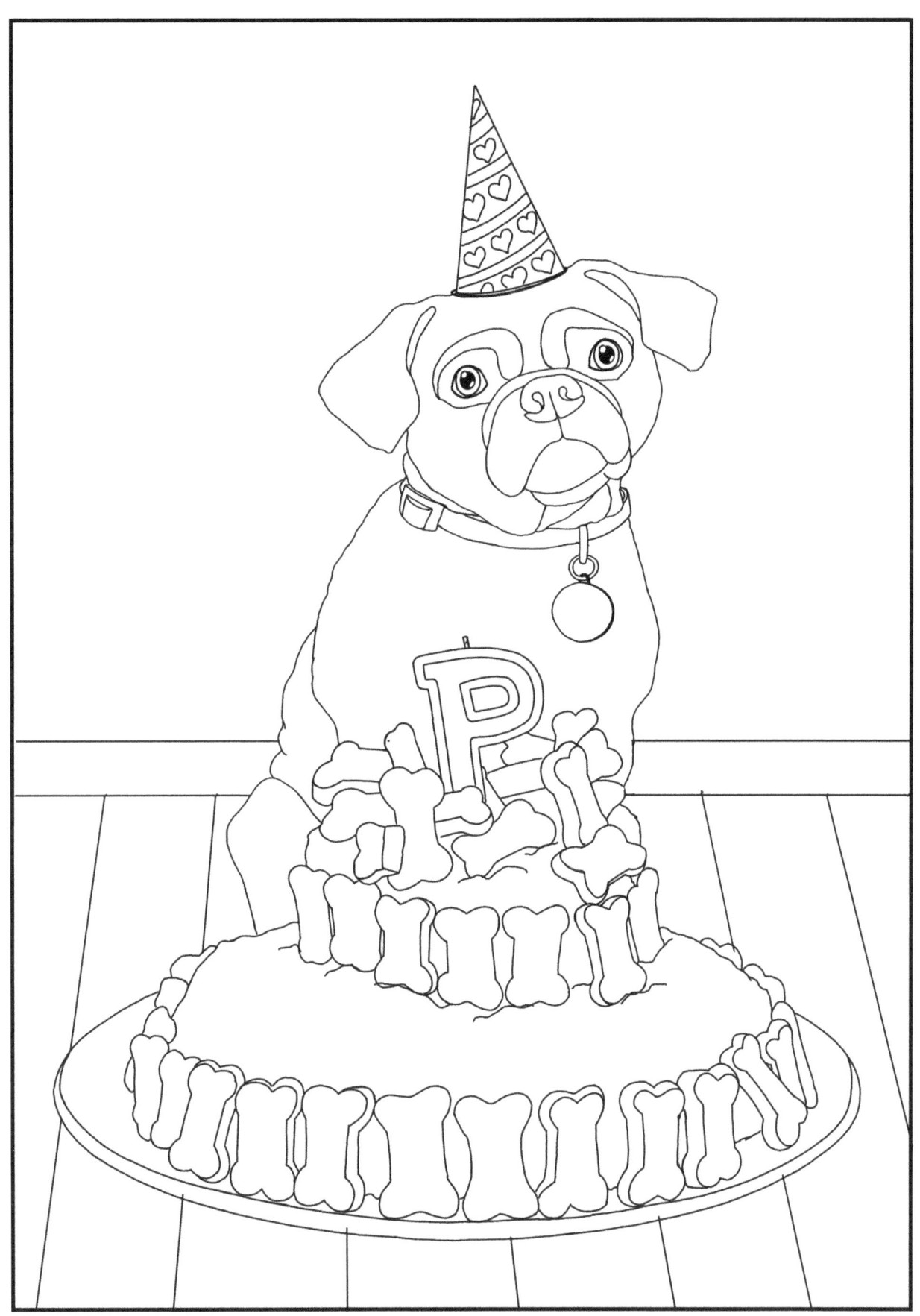

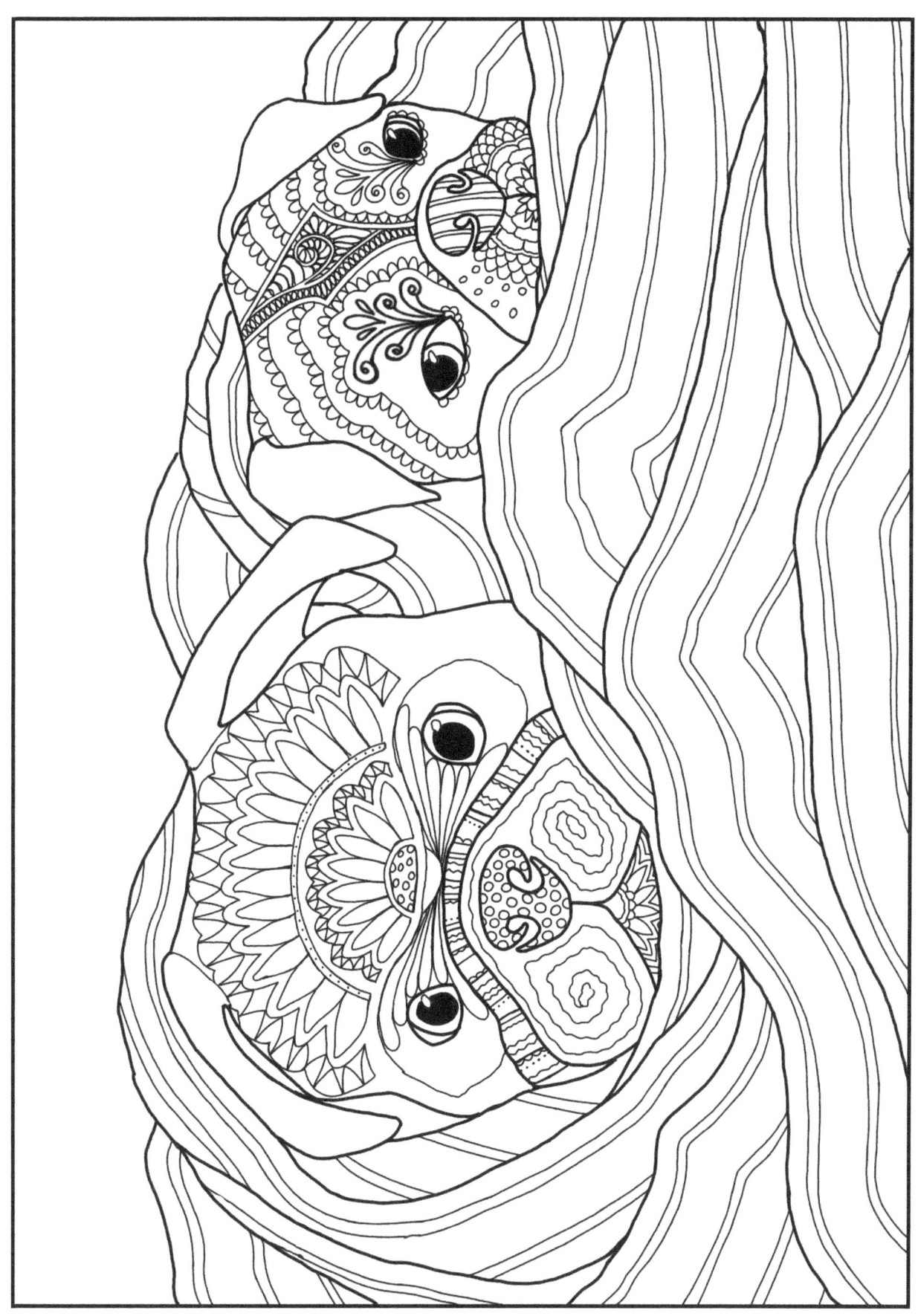

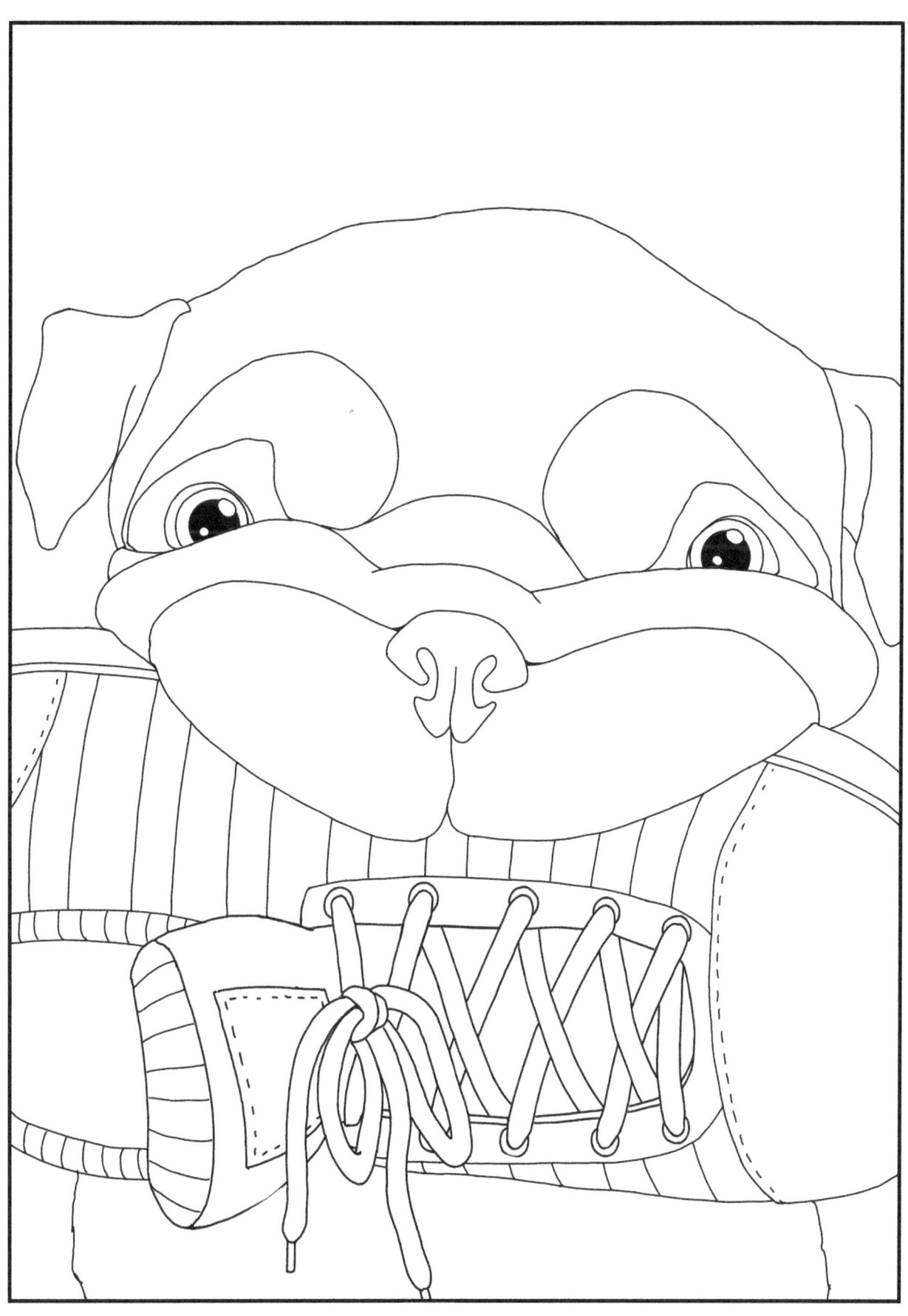

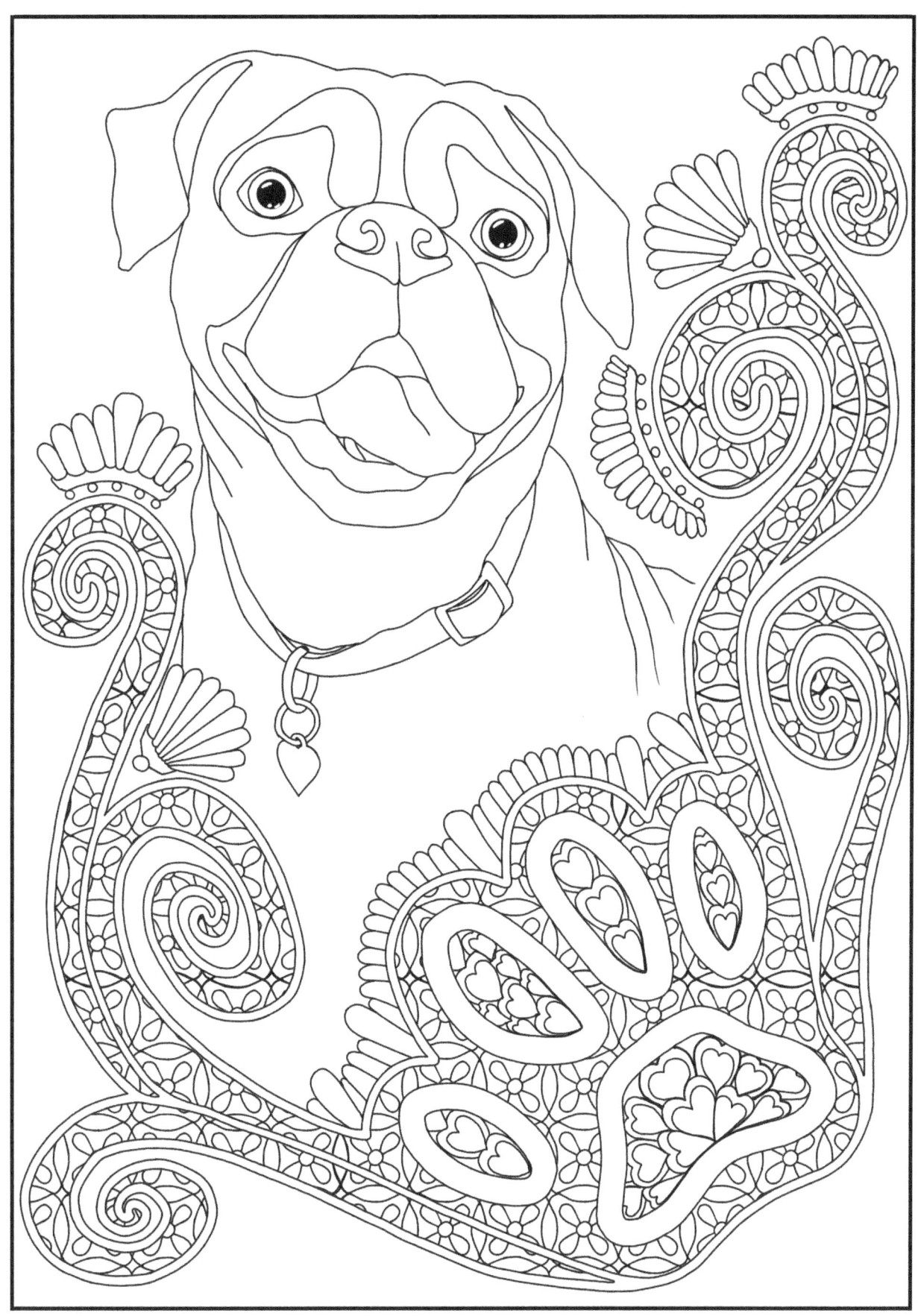

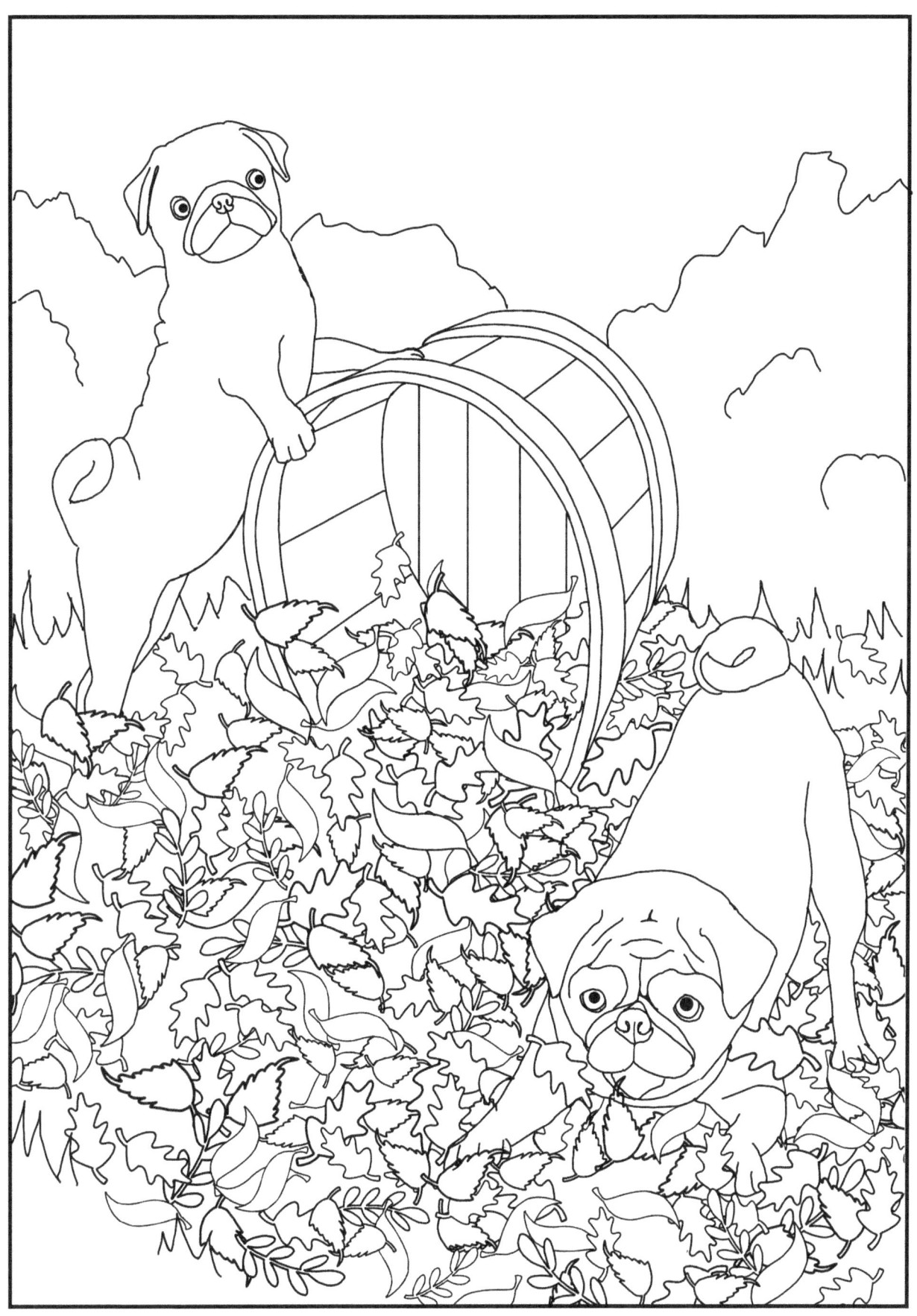

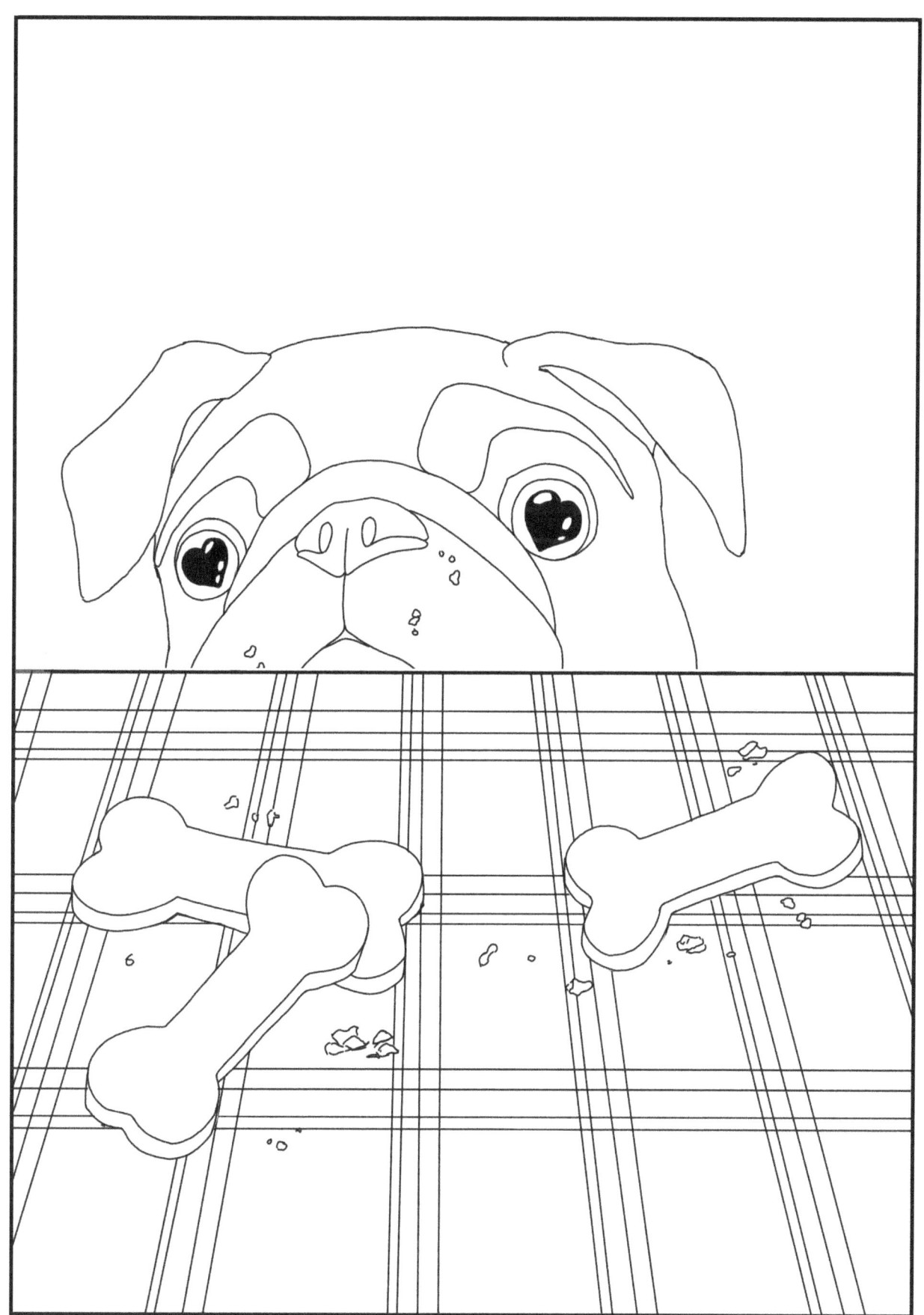

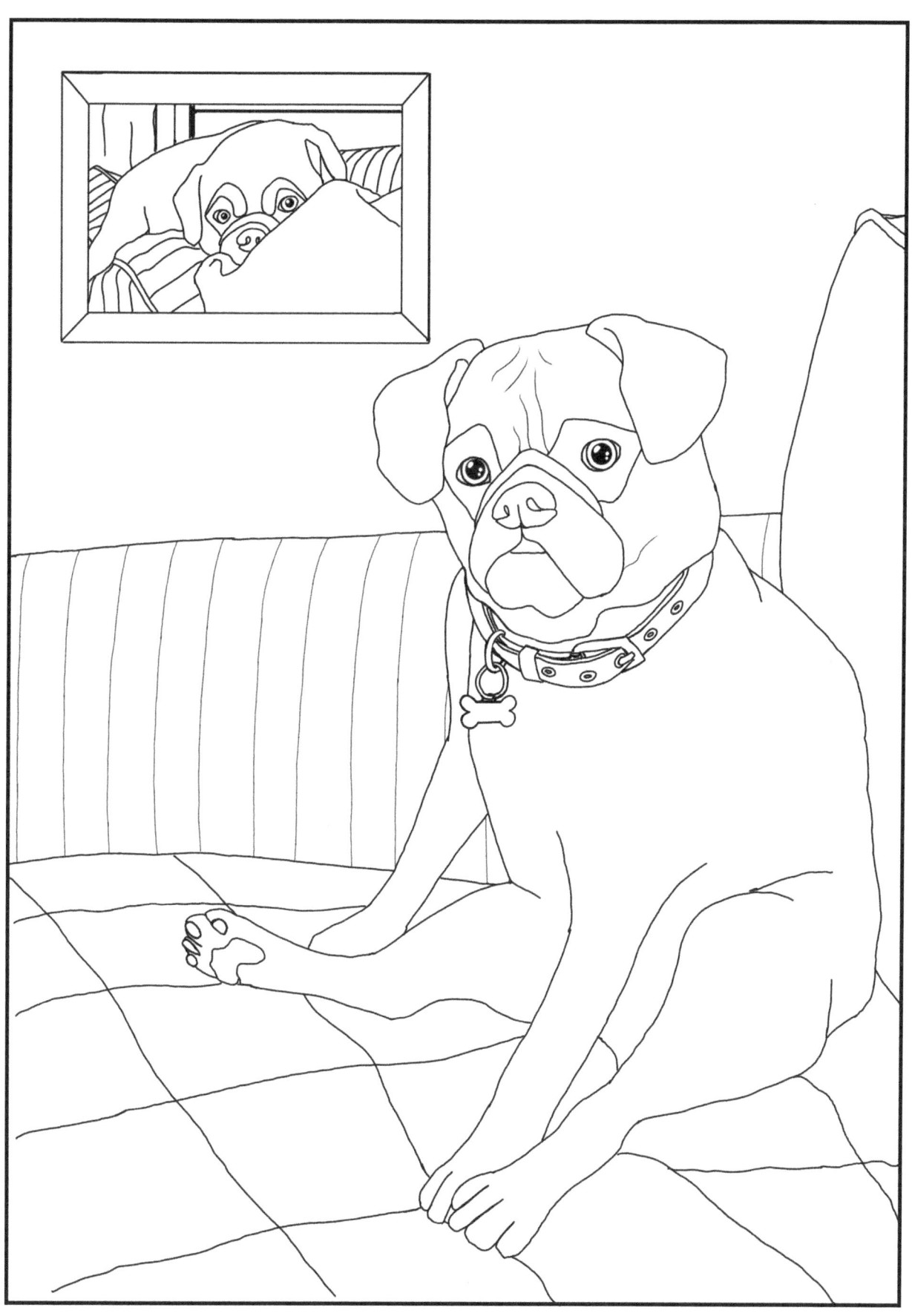

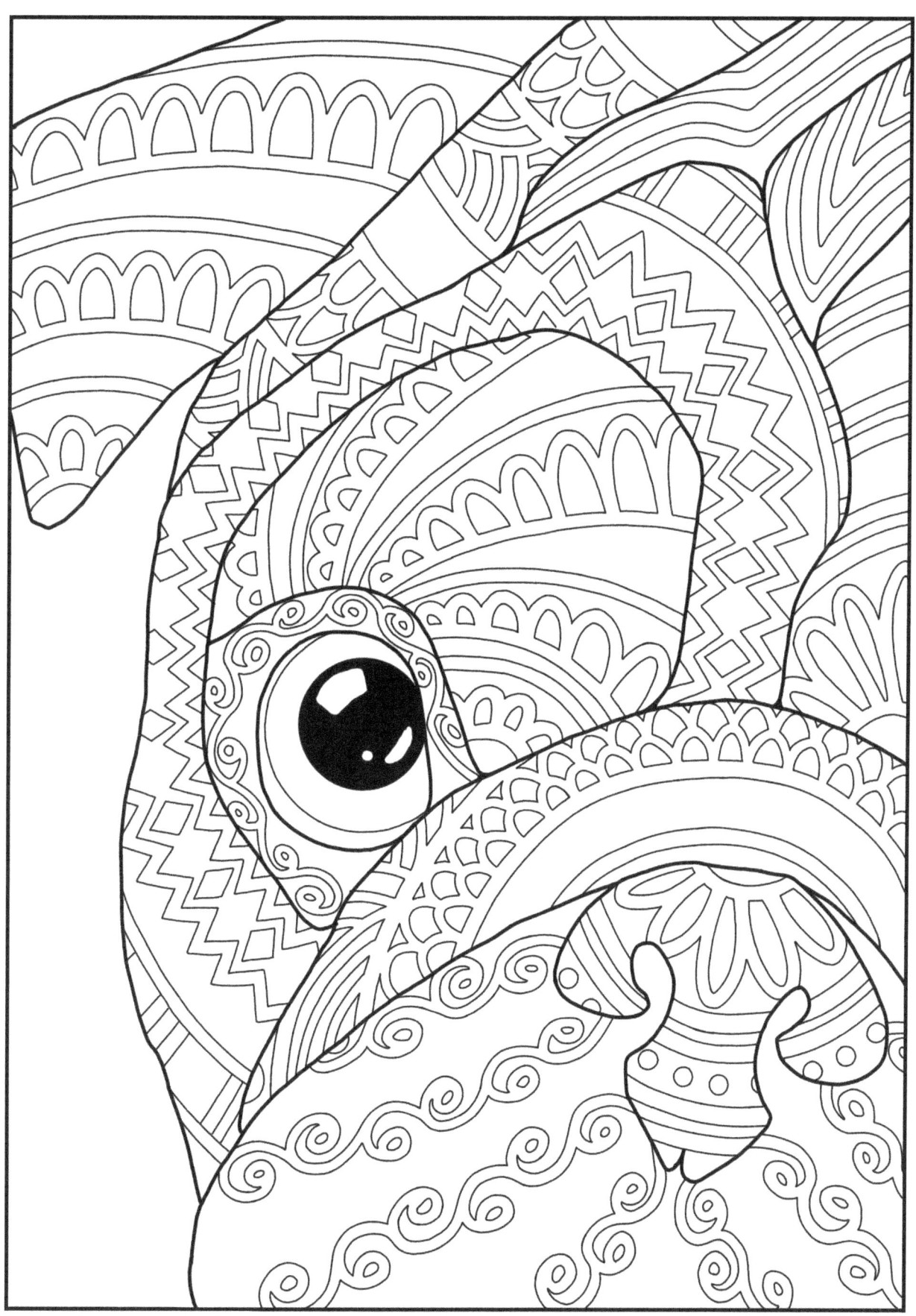

Get FREE coloring pages and connect with others who love to color! Share your colored images in our Facebook group:
facebook.com/groups/MindfulColoringBooks/

For news about contests, giveaways and more FREE images, like us and join our email list:
facebook.com/MindfulColoringBooks/

Shop Mindful Coloring Books:
amazon.com/author/mindfulcoloringbooks

Enjoy these preview pages from some of our other coloring books!

Cute Baby Animals Coloring Book

Relaxing Coloring Book for All Ages

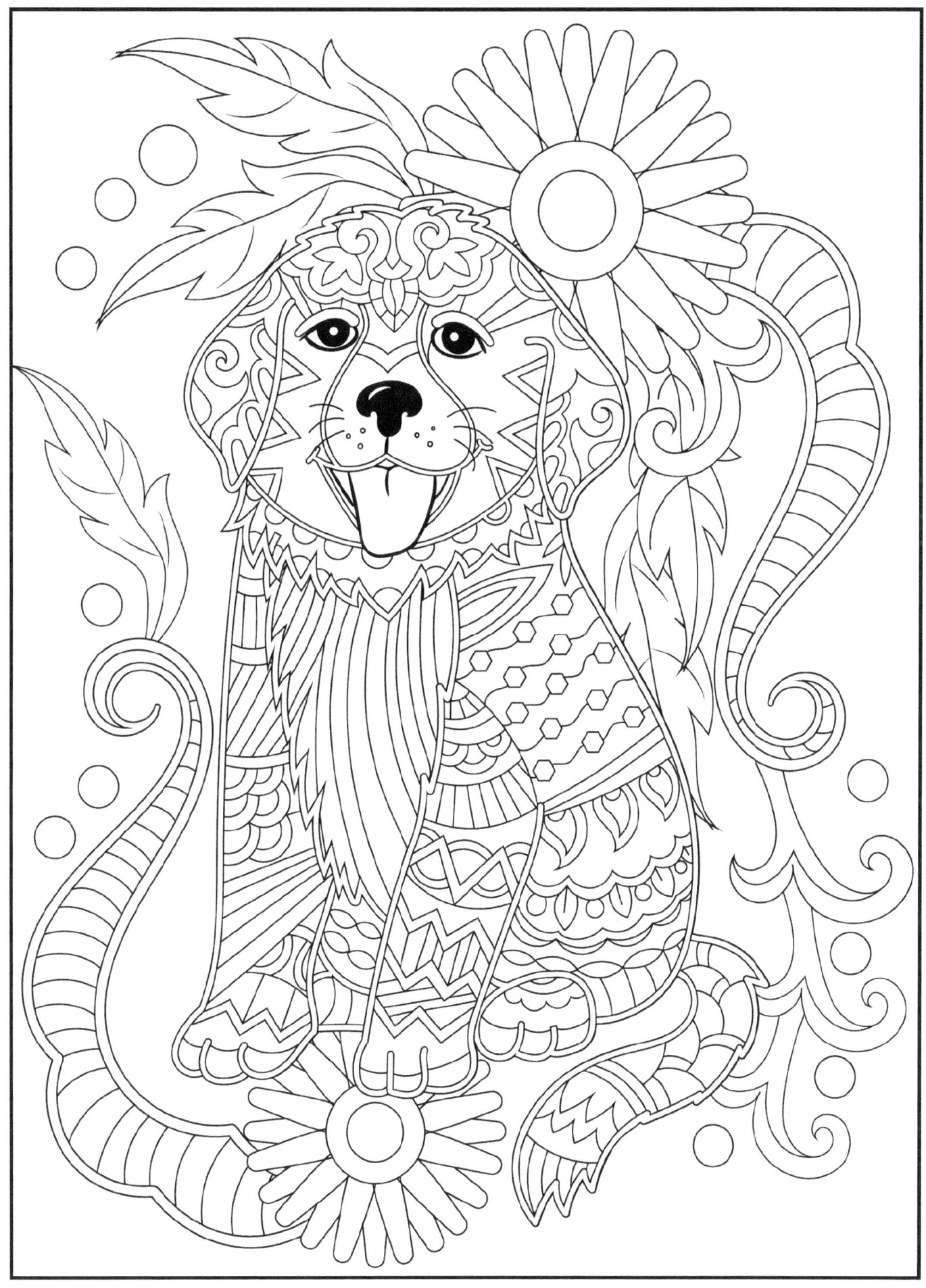

Serene Country Scenes Adult Coloring Book

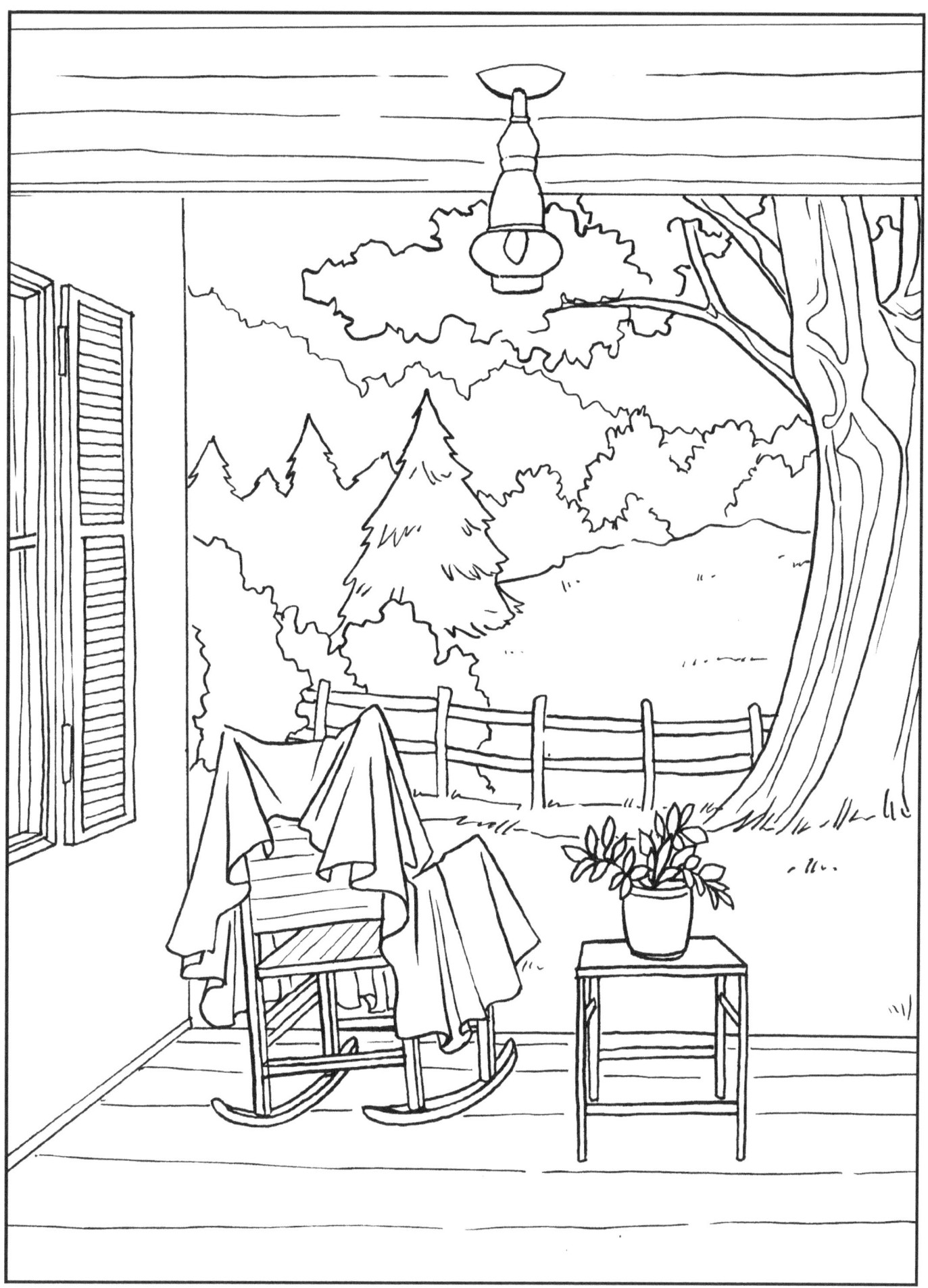

Free Bonus Stuff!

Color, cut out and share with your friends!

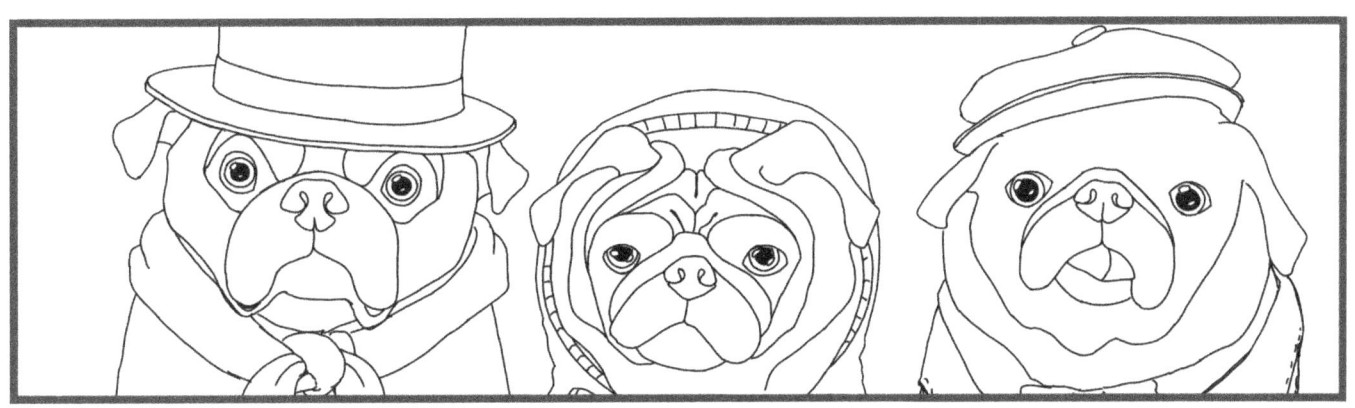

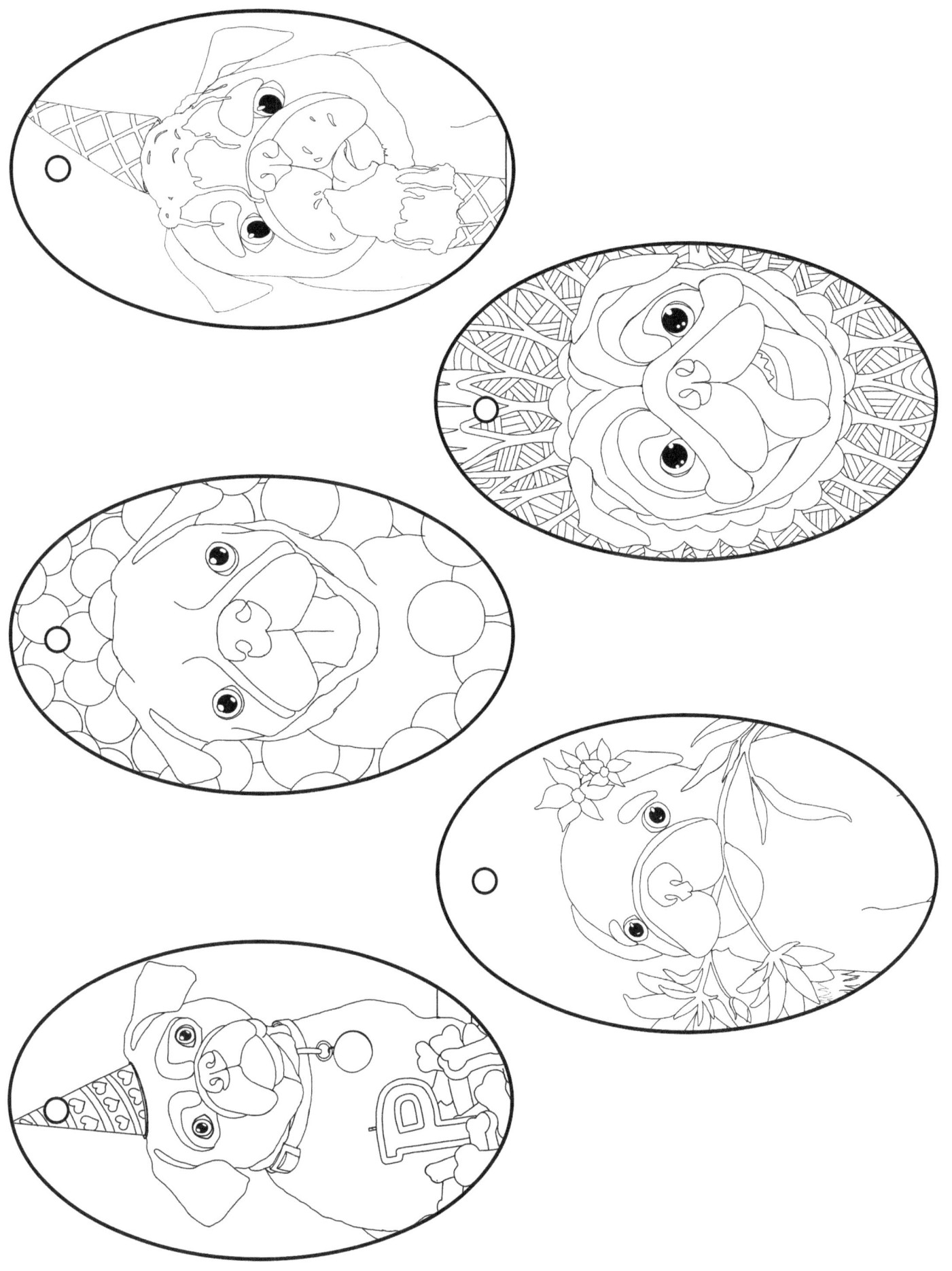

www.ingramcontent.com/pod-product-compliance
Lightning Source LLC
Chambersburg PA
CBHW080545190526
45169CB00007B/2647